Greer Lankton
Sketchbook, September 1977

T0044213

Primary Information, 2023

<u>Sept 9th 1977</u> 7:00

[Br.] orange Juice, Apple Juice, Green Pepper

Bagel — High Protein Wheat flour, water, sugar, salt,
fresh yeast, pure vegetable oil, calcium
propionate.

Bologna (Took Sumycin
 Theo + Iso)

Spinich salad, sprouts, water chestnuts
 french dressing

——— rode bike to train ———
difficult breathing pasty skin
ears "opened" into my breathing so
hearing was difficult

Sweated most of the day
much mucas in lungs (Took Sumycin
left school early after [Lunch] pie Green pepper Theo + Iso)
 Apple plum
Thristy Honey crackers
——— rode bike home ——— water
felt a little better

exercised and cleaned room + studio

drunk <u>lots</u> of water throughout day

mucas cleared up

hyper - energy — End of Illness, spurt of Health

 (Took Sumycin
 theo Iso)
[Supper] Ate some Bagels (2)

slept with vaporizer on

 (Took Sumycin
 Before Bed)

went to sleep at
 4:30 in the morning

Sept 10th 1977 7:30

woke up refreshed (Took Sumycin)
Took a 45 min walk around P.F.

Nose got runny - (Took Iso.)
skin dry but /clearer scalp itchy
[Br] orange juice, water, canteloupe

rode bike to Library around
10:00 stayed till 12:00

(Took Theo)
lungs started to fill with mucus
stayed relatively calm a little ear
 trouble
went to Plaza to do errands
rode bike home - stopped to drink
 peach juice
lungs thick + rest

[Lunch] 1:30
 Hamburger - salt pepper dill weed

 Peach juice [Sumycin]
 weverly cracker

vaporized lungs

 5:00 [Sumycin]
[Dinner] fish, sprite, apple Iso
 donut The

7pt Baccardi Rum
 Life cereal

 1:30

Night – lungs are almost closed
 but I try not to panic
 Used Vaporizer

Stopped using soap on my face yesterday
 Face is plumber + healthier looking
 acne is better
 zits came to a head which popped
 almost naturally

conclusion: Mold, Dust are present
 <u>everywhere</u>

 <u>Trees, Grass</u> are in bloom all over

 So Alas my environment is totally
 contaimencuteed.

Solution: stronger
 Drug to control Asthma

open Lungs—

Tranquilizer to calm Fear + panic
 due to loss of Oxygen

& cannot <u>constantly</u> pick through <u>all</u>
my food.

Be microscopic about all articles
 And how does one avoid Grass
and Trees when their on either side
 F the sidewalk.

A clue

Mold — green stuff - fungus —

— Chris Royer —
High - Fashion model

Does this cause Zits?

Dolls
| wire Foam - sometimes used.
old T-shirts

painting faces water seeps into foam
IE doll is then put away the doll develops mold

I remember telling Joyce once to excuse my behavior while I'm working on dolls because the excitement overcomes me. I also have found that I don't need sleep or food when I work just liquids. I work very fast. Is this a reaction.

mold in Food

old in sweat - Exercise Difficulties

Lungs are worse in city?

Under any stress lungs react

This is serious.

Haven't eaten eggs in 4 days

Helpful	Harmful
water	Milk — Butter?
Vaporizer (How about Asthma spray)	Egg?
Keeping stomach full	Mold — old things
exercise— If done calmly with much preparation	Trees
Theo Iso a little Help	Grass
Rum — clears mucus out	Stress
Relaxes lungs throat	Depression
chewing Gum — Ears	Rushing
Clean Bedding	Dehydration
Clean clothes	Smog
	Stopping everything — like trying to sleep makes lungs worse

Sept 10 1977
 I.C. Home
Day One ··········· S.A.I.C.

Put myself through much stress and
went through a whole array of emotions
with my parents yesterday..
I am to soon start Allergy detection
and visits to a psychiatrist.
Hopefully to straighten the confusion
and ease the pain. Im relatively
calm right now. Calm because there's
no ~~sweat~~ sweat on my brow and
the beating of my heart and lungs
has resumed its normal perspective.
I've have mostly controlled the
beast today. Talked calmly with
Marie. Joked with Nicolas. Carried
on a conversation with Alex, joe
and Pam all at once. Bought supplies

Nothing major but enough.
Words come slow today mostly
because they are inspected before
dismal. I ~~always~~ also watch
their action and the subsequent
rebounds. Perhaps I have learned

to Listen. I learned about many things today.

Sept 11th 1977

I am truly amazed. Its as if I'm tripping on very strong acid. Well mild acid is more appropriate. Of late, since breakfast I have become highly focused in a seemingly grown-up way.

I ask is this truth? Is this to be my reality? Have I opened to a concept of whole or perhaps the opposite. Have I retreated totally for now into a world of largely my own making. If so is there a choice. Thinking more on this it could be an opening and a closing which takes place but which I feared and therefor repressed.

When fear leaves, one is open. There's was no choice except the choice one can make and that is to say. Fuck the fear thats uncontrollable.

Fears purpose is to caution one to a danger. However it often outsteps it bounds infringing on it's owner's happiness and growth. Fear becomes an emotion that aims at destroying the emotions that otherwise might interact with surroundings and thereby cause

the owner to enjoy a sense of living.
Fear is death. Except Fear allows
one to continue physically living but
not mentally emotionally. Its a
sense of torture. Of endearing
shuffling through. No it causes
one to run, to dart, to suspect.
It drives one bat-city. However
Death is not so cruel. or so it is
What I would like to believe. Death
ends the reality. Does it?
I seem to continue regardless of
whether I'm this or that. I spend
so much time wondering if this
or that is better or not. Would
I like this. Or perhaps that.
Is there a choice not to decide
But that becomes a decision too.
So must one assume this, that
or the consequence of neither or
is it that there really is
only a this + that and no
between.

♫ "This or That or in between" ♫
A song and dance done with taps.

o well.

Time has ~~bee~~ taken on a new
feeling for me.
Time was something you fought
against.

Time continues regardless so the
fight is not neccessary, not
productive and not fun.
of course one doesn't always have
to have fun.

Time is something you can
ride. It glides eternally.

One can chart a course through
time.

would one rather hop on and
just go or sit, ponder, go

probably a combination would be wise
to sit + ponder sometimes and
sometimes just jump aboard

one must lose the fear to know
to grow.

Then one becomes insanely
glorious has ones ride deepens.

Also embellishments are an extra
excitement along the ride.

so guilt with indulgence
becomes yet another unessary
useless tool to building a
comfortable seat along the ride.

This is quite a help to think
about.

One can go anywhere

But please lets not
be too reckless

Sept 11th 1977

Night. A day perfect in every aspect. Have I become fanatical in my search for purity + perfection. Alas a feeling of contentment overcomes me so who is too care. The more I question + search the more things open. so many cliches apply.

I have a slight fear that I have set on path from which I will not waver.
However it is my path so as Byron said today in class concerning being commercial or independent in the latter one only has oneself to answer too. A relief.

A true relief

Sept. 11th 1977
8:30 (Sunny Iso Theo)

[Br] mushmelon —
water.
dry life cereal
bologna

awoke happy - a 1st in a week or 2

rode bike to train — bought orange juice

on platform after (O.J.) — lungs started to
feel think

runny nose — [ISO]

on train now I feel drugged
like a very mild mescaline trip

Focased on being very relaxed
constant relax reassurance

[Lunch] 12:00 life cereal lots of orange juice (?)
bologna (Sunny Iso Theo)

lungs were always waiting
if I let down for a minute
my lungs would stop
slow small breaths
Rubber - Like Mucos
[Supper] spaghetti - sauce
Tossed salad w dressing . roll
fruit mix Ice Tea

careful to avoid dust when
sewing (wore a mask) kept drinking IceTea

My symptoms were a
manisfestation of
what I thought other

people thought I

was to do.

one has the chose
to learn or not learn
from any situation
and thereby take

the consequences

I have

In Intellect I know
Now emotion etc. etc. etc.

Rember :
Never to
stop
but continue
in the
thing you have chosen
if that fits but

Beware of going to
an extreme where
one has no
choice.

A too early choice
limits or expands
the creative flow

of the Artists
rythmn. As Dennis said
last night — Don't
Hern and Hay say
what you whont
this applies to a consept
and also
a style.

My style is irrelevant
now that I have
a source.

sept. 12th 1977

I have myself and I
would like no more input of
self.

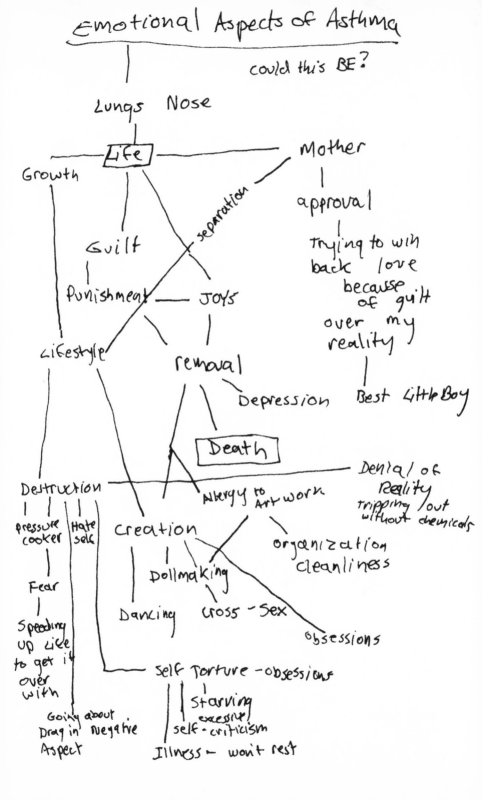

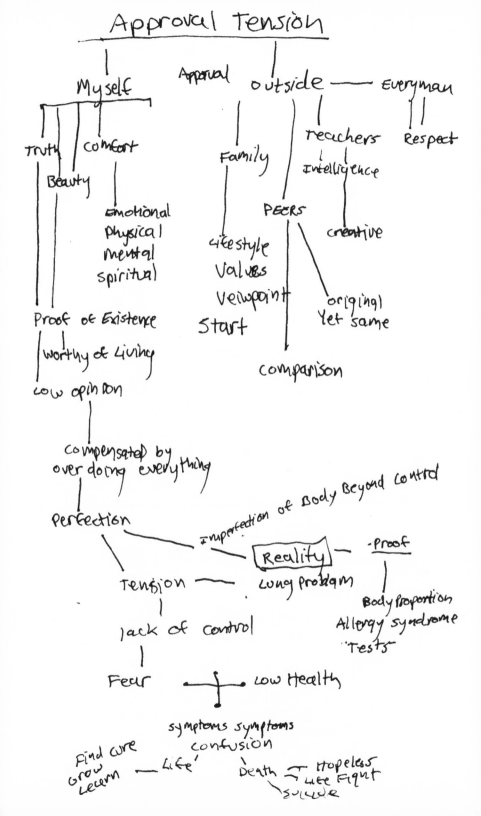

Relax	Tense
Uncluttered	Frustrated
clear	confused
Rational	Distortion
seeks to solve Fast Easy	Exaggeration
Insight	searching Madly Reading countless Books
Growth Experience New	Symptoms anxious
Art Personal Physical mental etc. etc. change variety	Death Cure after cure after cure
to go on from mistakes Depth	Paronoia
opens	closes

I'm not looking for an end to
Life's worries just an end to
the ones that are unnessisary
and counter-productive.

one cannot think in terms of
good or bad for everything
some things just are
acceptance

when one opens one has the option
of friends, lovers, experiences, etc. etc.

when one closes and narrows one
has no option to go and do
one sits + stews

 material
 Needing them to live
Possesions — As a proof of live
 | Become a Burden
Having oneself Tieing down
Joys

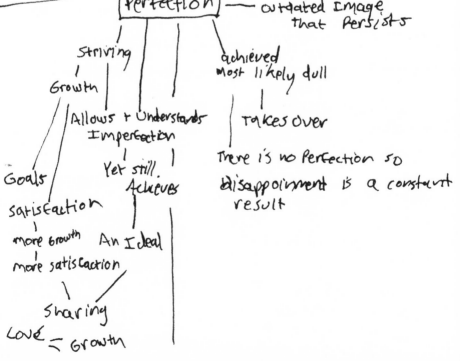

Perfection — outdated Image
 that Persists

Striving achieved
 | Most likely dull
Growth | |
 | Allows + Understands Takes over
 | Imperfection
 | | There is no Perfection so
Goals | Yet still. disappoinment is a constant
 | Achieves result
satisfaction |
 | |
more Growth An Ideal
more satisfaction
 | /
 sharing
Love — Growth

Self-Image

Strict

Male Female

Loose - Flowing

Combination
of resources

content ment
with
self

This or That

Extreme Fluctuations

constant change
adjustment

confusion
|
sex change
|
to be the woman
kill the man
|
Vice Versa

Propaganda from
Early childhood
America
Reinforced in
Gay Culture
resulting in
a gay neurosis

short hair
stubble on face
rational
arrogant
sexual
athletic

Long Hair
make-up
Body Held loosly
arched shoulders
slow Graceful
Nest-Building

sensual

sticking together
pulling each
other
done

as opposed to
questioning and growing
up

one
can still be
wearing make-up
and flaming brightly.
but as a choice not tool to keep one down

It's not the drag that sinks the queen it's the acceptance of the guilt and shame one feels one must have. This is consciously or unconsciously put out by parents, peers, media doctors, moralist etc. etc. ...

If a man wears a dress and thereby offends parents peers etc. etc. is he at fault? His choice is continue and ignore the abuse, question, grow, fight or give in and deal with the frustration. Or is a compromise in sight. With courage and patience one can gather a small circle of friends and live happily as one wants. This means limiting ones choices of jobs, living areas etc. However it also can

mean finding a self one is
happy with and growing
to full potential. Do
people have to have an
explanation to other people's
behaivor? Does this limit
their own Growth?

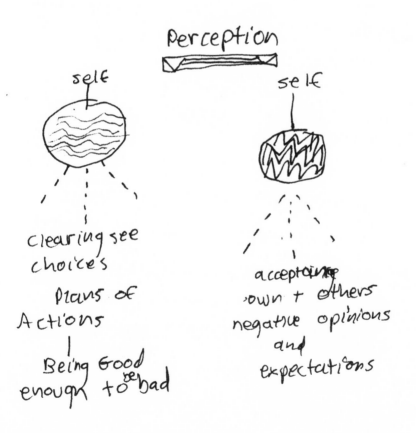

Perception

self

self

clearing see
choices

Plans of
Actions

Being Good
enough to bad

acceptance
own + others
negative opinions
and
expectations

It's no-ones business if I
choice to do this or that

Guilt is the best way
to pacify the individual

American middle class aims
at taming the wild
beast to be best
used for the corporations
interest and the chosen few..

The individual aims at self-
growth which also benefits
others as it allows for
self-growth in others

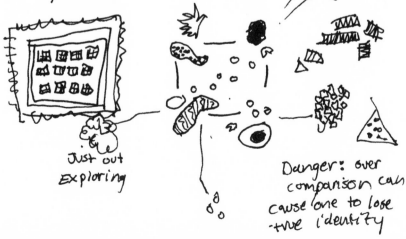

Just out
Exploring

Danger: over
comparison can
cause one to lose
true identity

Eccentricity		Decadence	
–	**+**	**–**	**+**
~~Truth~~	Truth	Stale	~~stale~~
Alienation	shoe fits	excessive	can open
self-Doubt	the foot		extreme
(w influence)			retirement

Normal		wholesome	
=	**+**	**–**	**+**
Trying to make	easy to	Too Good	Health
the foot fit	Flow	Narrow	
the shoe.	(at least for		
conformity	a while)		
and loss of			
identity			

Growing up

Transitition

A Fear ε Leaving Behind

Alas Leave the Negative
and continue the positive

zits

Doubts

Puberty

Nervous Ill-health

→ Growth
..

awkward

Guilt

conception
developement
Birth
Toddler
child

narrow veiw
choice
range

Teenager
Young Adult

not neccesarily
correalated
with years

Adult

middle

You can go
forward backward
up and down

old

Death

as yet unseen by this
veiwer

within each person is a cast of
characters

enough for now
sleep calls
renewal.

Sept 12th 1977

Limits for growth are set
mostly by ones perception....
very evident in Ammm Art that
we saw at museum S + I

Leonardo De Vinci realized this but
alas also knew mortality,

my vocabulary is what
also limited my growth giving
me only a _set_ range of
emotions experiences etc.

what couldnt be
classified, catologue etc. etc— was
not dealt with leaving

only a small range of choices.

This however does force one to really examine closely what one does choose to keep

In the sense of objects such as a newspaper article etc. etc.

It's impossible to keep a constant record of experience every second as evidence of that experience

The Brain can hold it but alas the hand can't. This is me knowing this frees one of the pressure of having to validate ones exsistance.

In a relaxed open state things sieft easily in a tight concined state things over power clogging up

many sides always

So if something is truly thought out, a _sense_ of timelessness is created because that _object_ can be examined many times with each subsequent observation revealing a new truth.

an insight

perhaps a chuckle

The multiplicity continues...
(work being a pain)

some people work to get money

some peoples money allows them to work (work being a pleasure)

or is it money doesn't matter then so it's quality diminishes

perfection as a strait jacket
perfection as a love
 a truth.

There is no good or bad
 only what each individual
brings to that experience
 that thing
 that that

 The limiting
 potential is outrageous

And do boys in the know wear
 white buck shoes?

 Basically what i've discovered
 is what Health really is

 mental
 Physical spiritual

It's no secret " Don't be too obnoxious"
 sure you just want to
 Help

The rich keep the poor in "their" place by withholding knowledge that is beneficial, by keeping the price of that knowledge above a level the poor or average person is allowed to pay.

This gives the rich an ~~exc~~ abundance of knowledge, which makes ~~ense~~ the rich person seem better when in reality the rich person just has knowledge. So in essense the rich have no secret.

The poor look to and envy the rich emulating them when in fact they

should be trying to get the knowledge not the wealth. The rich are brought up to believe their better so as they mature they must maintain this position due to a basic lack of true believe in self. while the poor as they mature do not need to be told they're o.k. they know. Of course this is very general and the Rich / The poor is not as strict / as it sounds in reality. Their are always exceptions. I think this perhaps is what applies to me and many of my

friends. Seeing as most my
friends are middle-class
white people from the
suburbs attending at
middle-class college..

sept 13th 1977
 I have finally made a step in
the right direction to rid myself
of the neurosis I devolped in
high school (inferiority/super_____)
because of the excessive
 teasing of kids who didn't
know and alas I didn't fully
either. Nor do I fully now
which gives me something to do,
 Exciting isn't it.

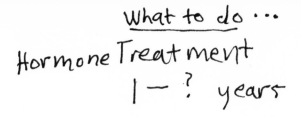

What to do ...

Hormone Treatment
1 — ? years

Consult
Endocr ‾‾‾‾‾
Alle ‾‾‾‾‾
Pysch ‾‾‾‾‾
Tran ‾‾‾‾‾

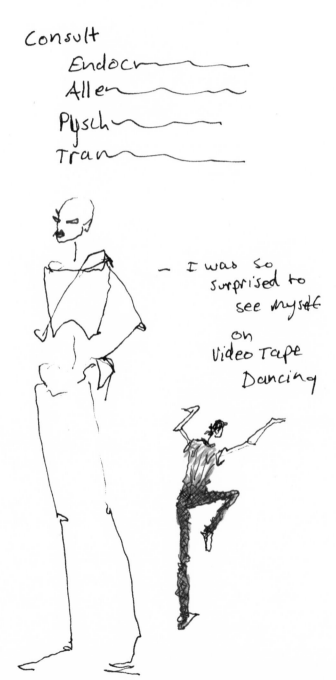

— I was so
surprised to
see myself

on
Video Tape
Dancing

this
__Explains__

[Linda] — me
\ Fear of
Men
Yet Fear of
Lesbianism

Allergy — Mother

Doctor, Medical
Obsession

Hatred of Women

Make-up Obession

Trying to Believe I was different
so different I couldn't
have a name — [Transsexual]

Idea of __Time__
being so pressing

one stops
at ones
level

The magic of 20

My unnameable paranoia
of going on as |ME| (boy)

seeing __negative__
exploitive transsexualism

relationship with Todd

hate / Love

[todd] being primarily attracted
to women [Bruce] - Gay
 Didn't
[Jimmy] being straight work-out
 1st lover straight men
 are
 attracted
Idenity with models to me
 or bisexual

My constant need to [John]
save anything to do sharon's
with sex change old
 lover
 [Sharon]- similiar
 to Greg

Relationship with Amy
Deteroated alot after her comment
"Transsexuals no matter what they do
 are never women"
Her arrogance as a women.

How I swooned when I met
 Jane
 Lisa
 Peter's Friend
 h Denise
Diannª

Dream night of the 12th

Felicia + Jane are
sitting from me going somewhere
on a train.
They stopped and
point saying.
"She is"

Art work in last few days

Pychsomatic pain all a diversion
from the truth.

Acceptance of self

—— stepping off the pedistall,
≠ made

—— The zap when I touched
Margy's skin
— strangeness between me + Lisa

what are the dangers?

possible

Job
Apartment
 school
 Friends

medical { money for operation

Hormone treatment

Dermatation

Pyscho { = Approval Testing etc.

when changing sex — one must realize appearance is very important at 1st then as one gradually grows into a women one becomes comfortable.

Even with a <u>butch</u> – a man
asked me if I was a women.

Childen always respond to me
as a women.

Ability to change
 and assume
 deguise.

One doesn't need the operation
 always

Hormones may be enough.

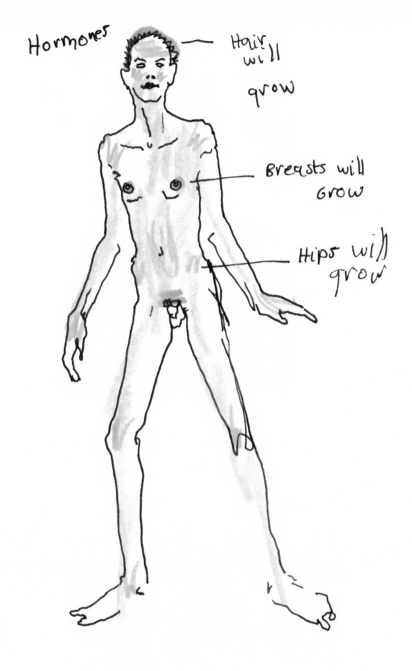

Hormones

Hair will grow

Breasts will Grow

Hips will grow

Books

"The Transexual Phena_____"
"Canary"
"Diary of a Transsextal"
 (Trashy)
"Christine Jorgensen"
"Conundrum"
"Year among the Girls"
 "Idols"
"As a Women"
 etc etc.

Models ...

Candy Darling — Dead
Christine Jorgensen
Canary Conn
Jan Morris
 Dennise — positive
Amanda — Baton
Chilli Pepper — Queen
Garbo — she personally
 feels she wasted
 her life
Maria Tallchief
Chris Royer — model
 etc. Jane
 etc. Forth
Linda Snelten
 Many Incrediable Women

Rapid understanding of "Women in society" — Class
 Amy
 Elizabeth } Year in
 L.J. Chicago

In hatred of self I
became a (characture of self)

I rapidly took a dislike
to gay bars

→ Also Rape with Apollo

→ Ann Shultz understood me
and saw through Hatred

→ ~~Bob~~ Exploitive — Drag Queen
Room

→ Suicidal
surrounding myself with Allergy things
mold
milk etc. etc.
destroying Health
sleep, exercise
Food
Destructive denial of Food
Sex situations hopes of thinness
ridding of male
mental Anguish
stress

Even without
 Hormones
 I have changed

[19] – little beard growth
 – low sex drive
 wide hips

Feminine Face

As David + Lex's
 friend said
 last year
"You'd be the
 perfect
 transsexual"

All of the sudden my
 scrapbook makes sense

well everything does
 that applies

 to me

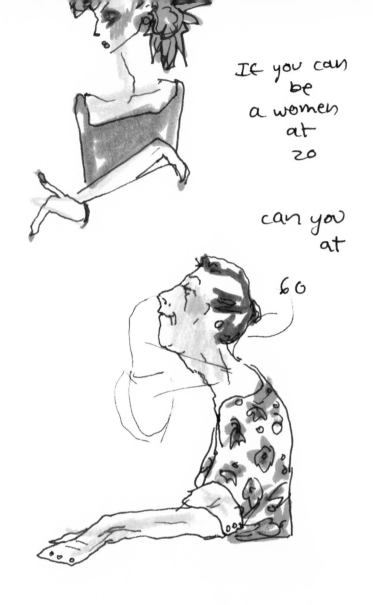

If you can
be
a women
at
20

can you
at

60

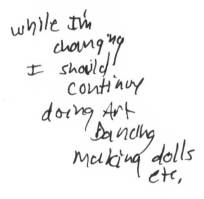

while I'm
changing
I should
continue
doing Art
Dancing
Making dolls
etc,

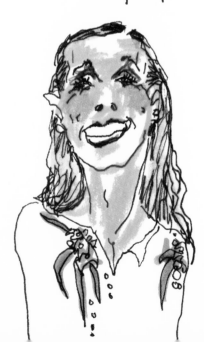

As a women
some men will
discriminate

As a sex-change
many people
will
discriminate

but alas
does it
really
matter

It'll be scary

Painful

Naturally
I'll be
miss Drama

Long

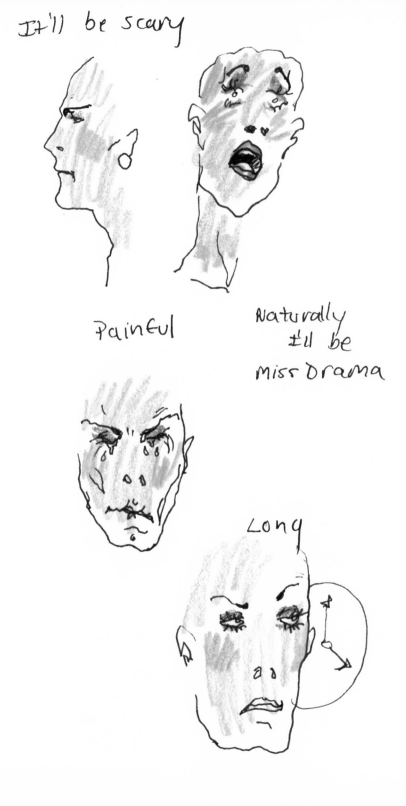

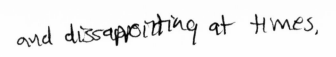
and disappointing at times,

It
couldn't
be
worse
than it was

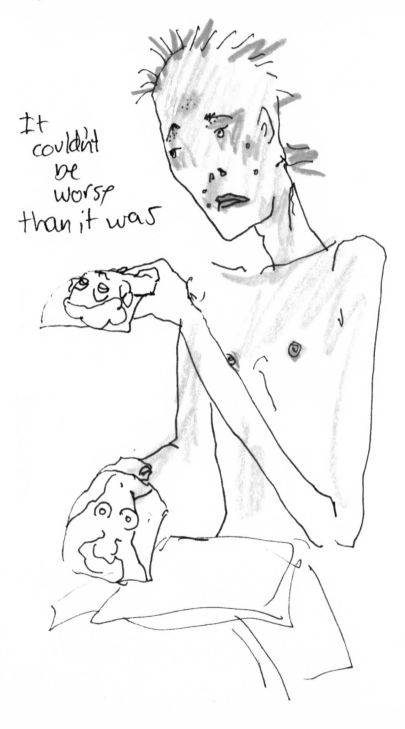

people will
 stare
 but they always have

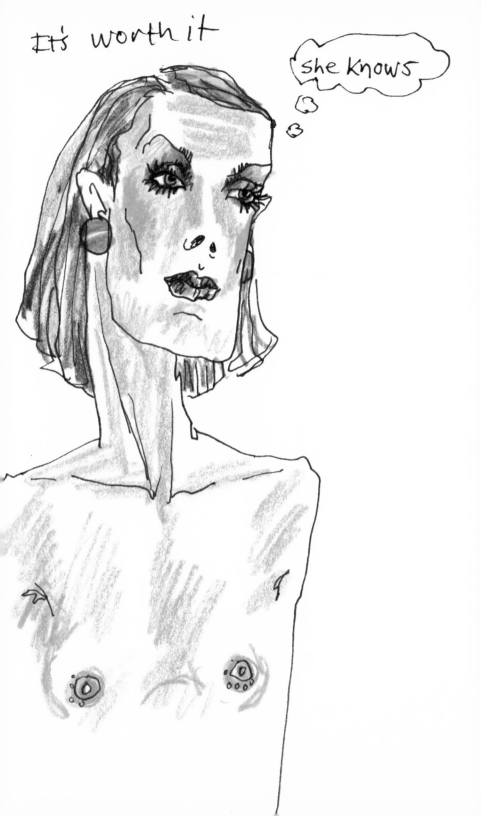

I will still be
 doing what
 I'm doing
only happily —
 +
 constructively

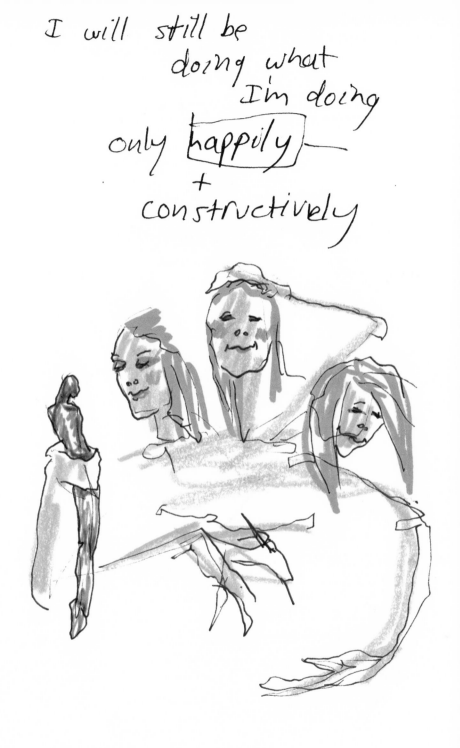

The worst is over
well it hasn't even
started by at least
I know

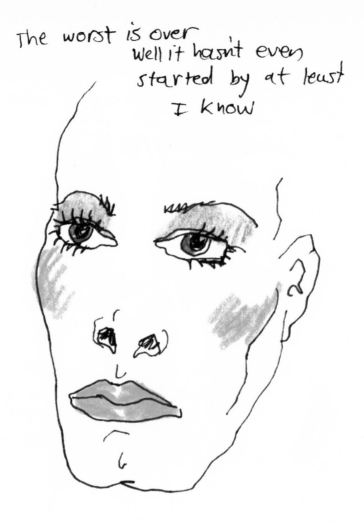

I probably shouldn't
 figure model
 during the transition

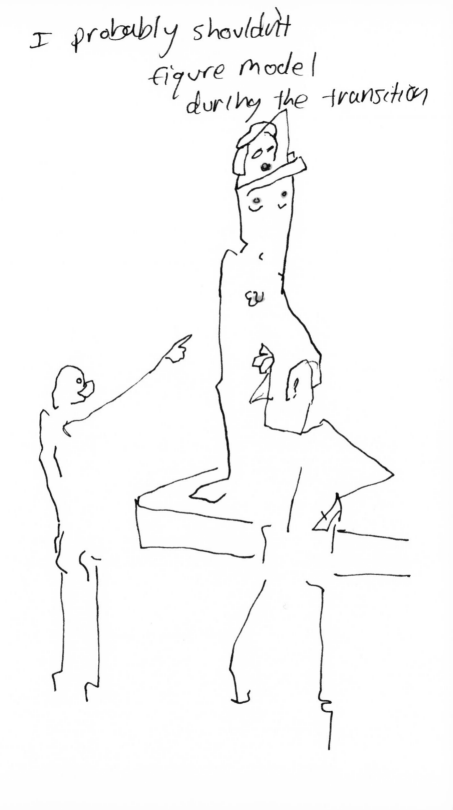

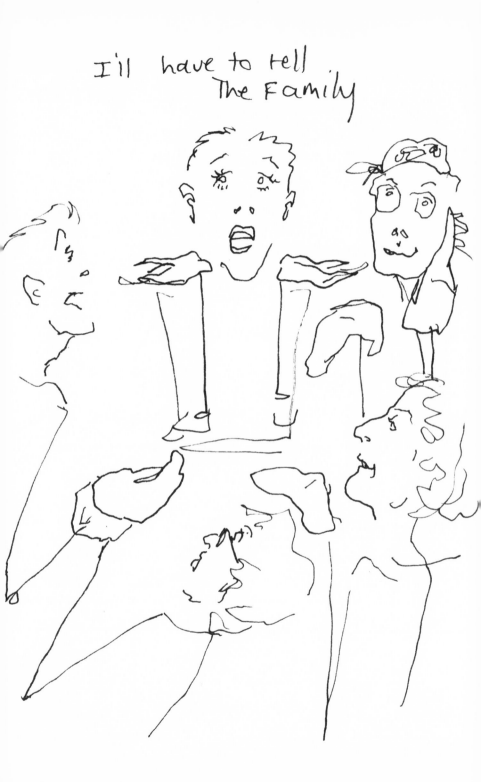

Friends

I knew
 something
 was
 amiss

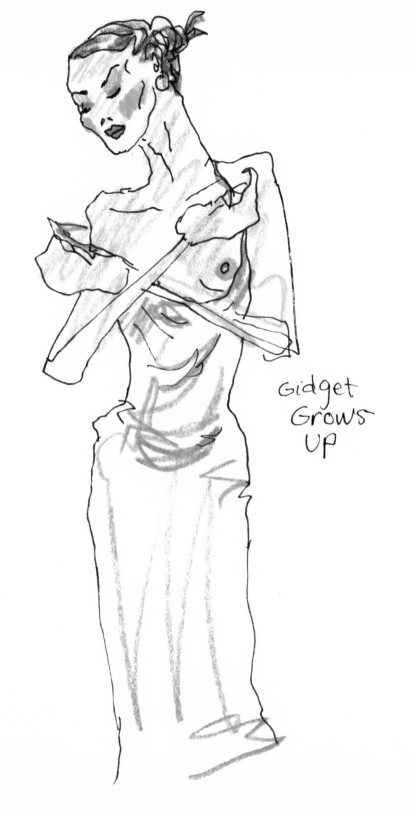

Gidget
Grows
Up

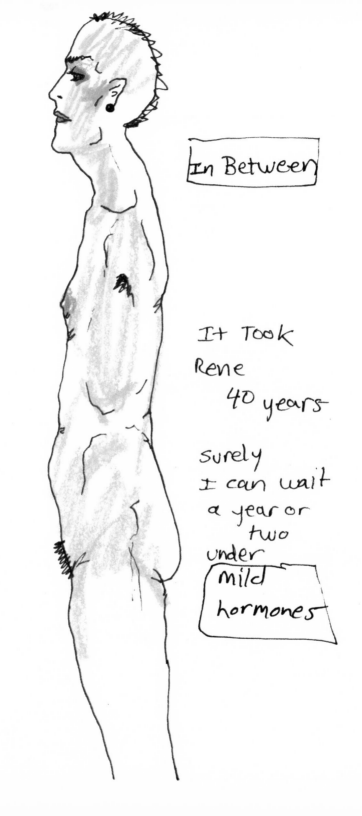

In Between

It Took
Rene
 40 years

surely
I can wait
a year or
 two
under
mild
hormones

As the late Great
candy said

"I've got
a right
to live"

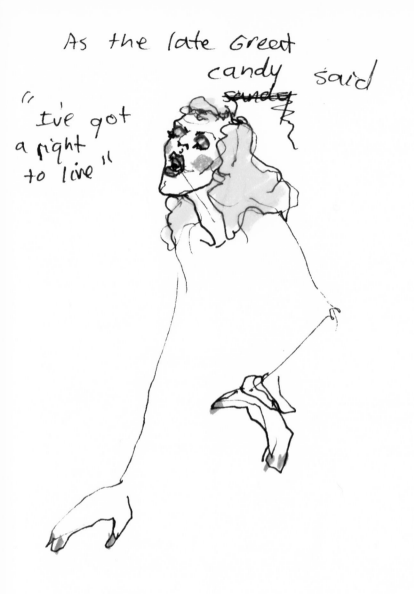

Dichotemy of Self

gullible seeker of truth

man/women
old/young
boy/girl
materialistic/
spontaneous/ascetic
|
Monk

How I saw

Nicolas

sumycin — skin

Iso — nose

Theo — Throat

mentel
physial health

allows one
equipment to
go—on

A ha another piece.

Greg

always remember to

__trust__

your intuition
its been
true __many__ times

— sept. 14th,

Alas another clue.

The [truth] is
"I'm Alright"
There's nothing
to prove.

This has hit so hard I can't
stop crying. Finally I too
can be human

I'm so glad I allowed
myself to step out.

Everything fits.

So many things were true
that I never saw.

God,
what it takes to realize
the power of observation.

Sydney J. Harris' column
strictly personal said it all.

I can't capture
his compassion

I now realize my limitations
as a person
also my potential

There's no way to thank the
people who had the
perception and love to
reach out and see that I
was hurt. And I myself
because of pride, wouldn't admit
it either.

I don't need revenge.

Words limit feeling
people
experience

I am sensitive.

There are no answers

I'm tired of questions

stable

Allergist | ½ pill instead of whole

chart — medicine

shots | Wednesday

Foods | Milk Fear

Eggs

Wheat Always Never

DOG

Grass

Mold

Dust

medicine

eat with medicine Sumycin
 Iso — Alright
lack of Theo
eating

EggsMilk meat
 Fowl
 corn

pear — cooked eatenfast → bad

caution: Exploitation of self

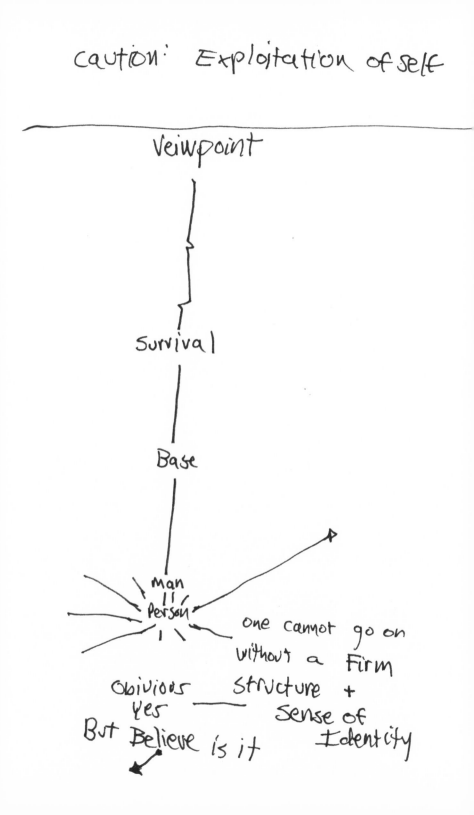

Veiwpoint

Survival

Base

Man
Person

one cannot go on
without a Firm
structure +
Sense of
Identity

Obivious
yes
But Believe is it

My asthma + my allergies are not necessary related.

The concept is simple

|

The form takes
on many languages

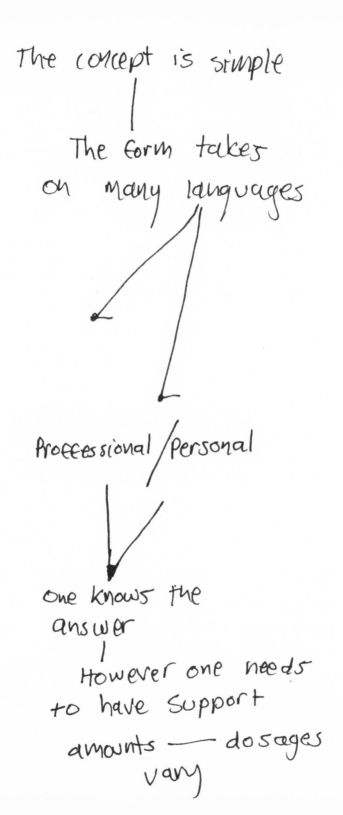

Proffessional /Personal

one knows the
answer

|

However one needs
to have support

amounts —— dosages
vary)

I must learn
 to apply
 this to other things
without _emotional_

involvement.

|

Artists need a reservoir

|

Doctors can only maintain
 the body if the

mind wanders

Which means what
 1) Death
 2) Survival

which comes back to
[transsexvallism] — Greg

Naturally I need
 communication
 approval
I ~~must~~ have taken the
 limit As far as
my emotional
 maturity will
 let me.

I don't _believe_ much
of the trash
 |
 not in parents
 language
 /
my own
 |
 body

If I know my body
is my own then
therefore I will not
do the obvious

|

Destroy

|

Anarchy

I'm tired of all this
Destruction to bring on
the new when the
new just repeats

the same fucked cycle.
I do believe there's
something beyond

my power

No Dear not paronoiq

But alas

A God

No

I will not solve this
for a *long* time

I will
solve the
problem of vehicle
Body / mind
split

No not schizophrenia
dear shrink

No not Asthma
manisfestation

And yet another
label limits
that But alas

Transsexualism will
ease the fear to
at least allow me
to funtcion

To function
I will think

Actions Will arise.

This is not new this
has gone on in

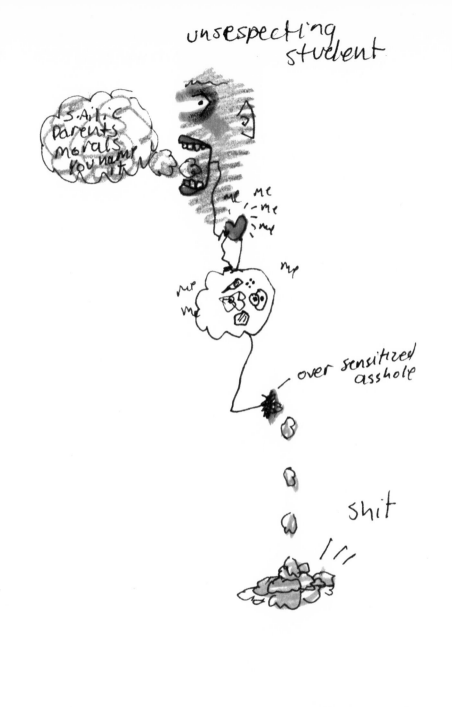

Suspecting student

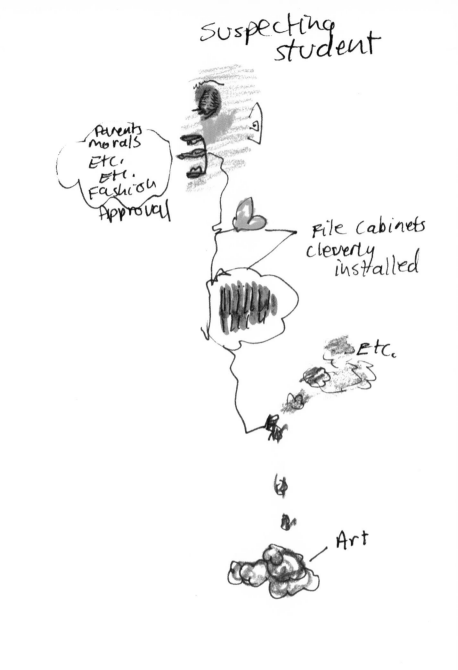

Parents
morals
Etc.
Etc.
Fashion
Approval

File cabinets
cleverly
installed

etc.

Art

One
Just
Learns
does the best one
can looks at
the rest
and giggles

Hopefully one does
not become a

characture of
unspecting self

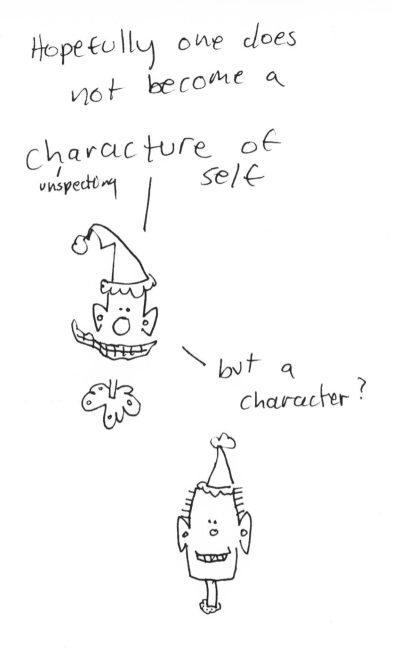

but a
character?

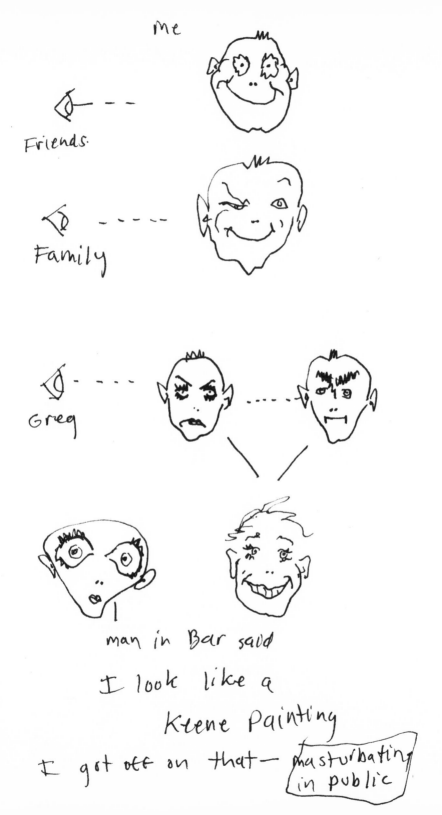

Linda's shoe's

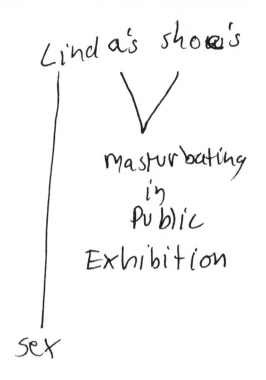

masturbating
in
Public
Exhibition

sex

o leave her
alone.

that's her's
not
mine

middle class spoilage

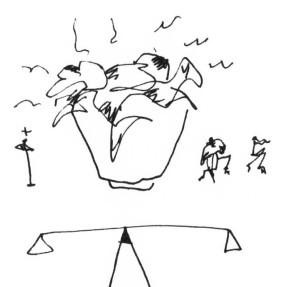

some
like
This

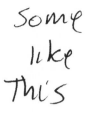

some
like
This

some
like
That

some don't care

many choices?

one day the boy went cross eyed.

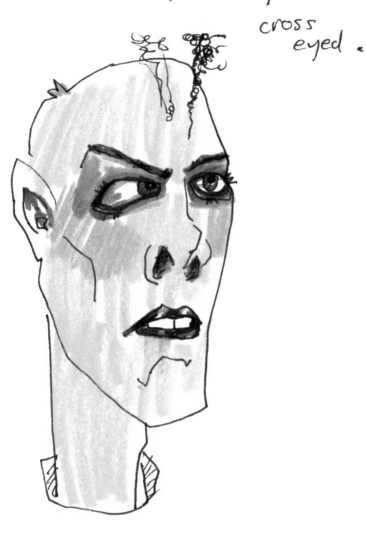

Formula 405

Funny Mothers

Intense Fathers

Middle Class Paronoid Art students

Heavy Morality

Introversion

Physical Deformities

Talent

Insight

etc. etc.

one
mixed-up brat
·with manifestations of

Asthma
Paronoia
Transsexuallism
Homosexuallity
etc. etc.
Etc.

Knowing what works

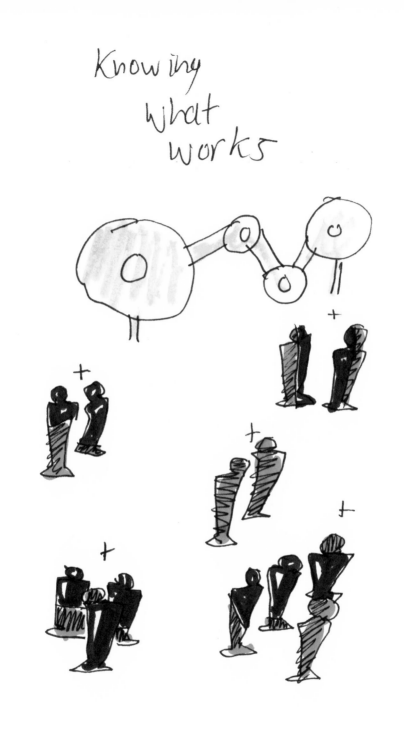

I'm trying
my brain
on
for size

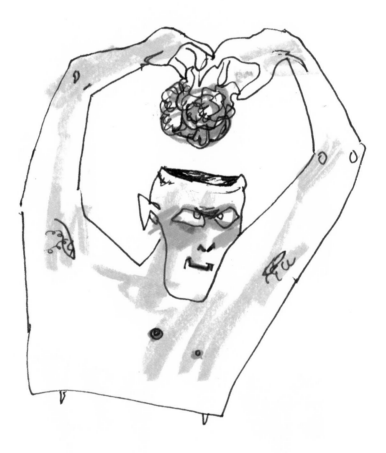

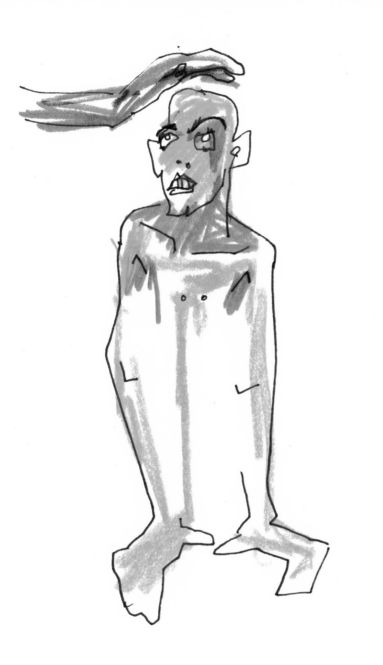

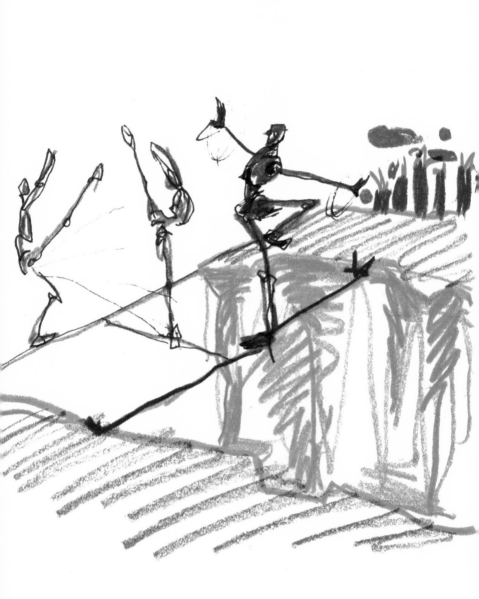

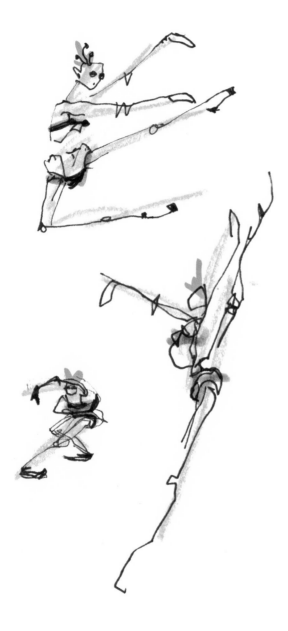

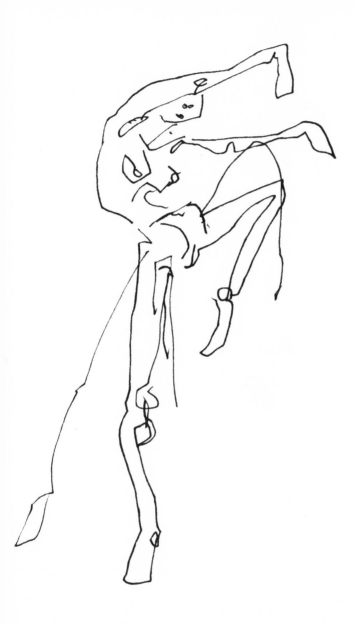

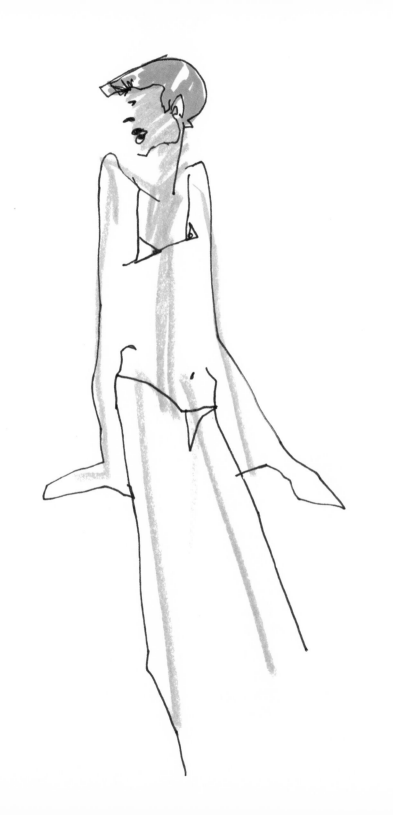

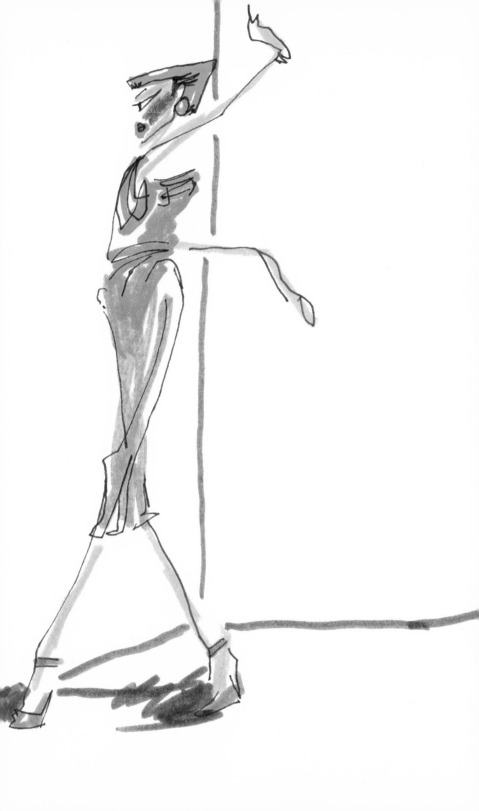

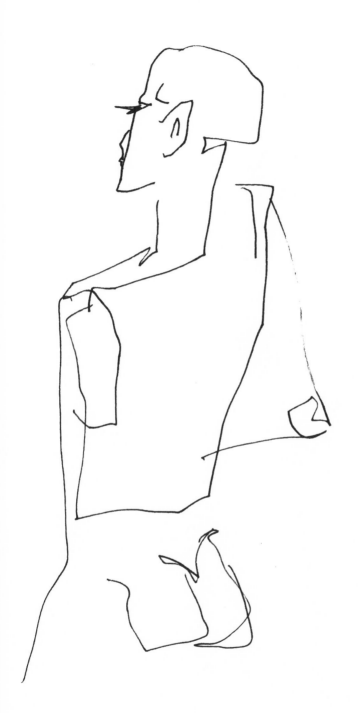

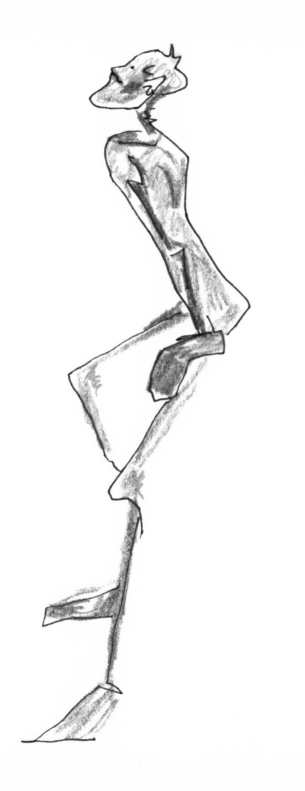

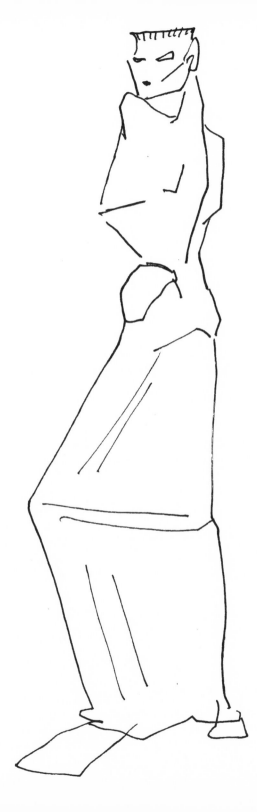

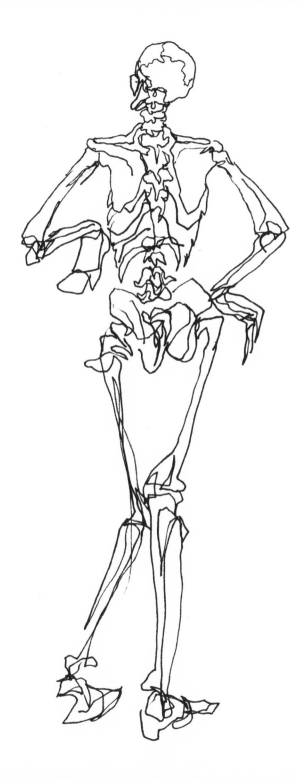

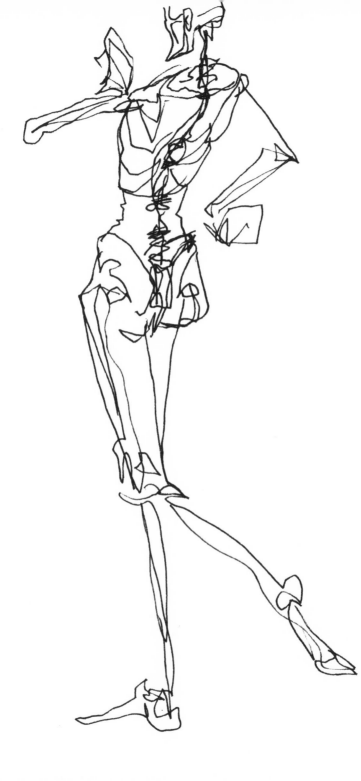

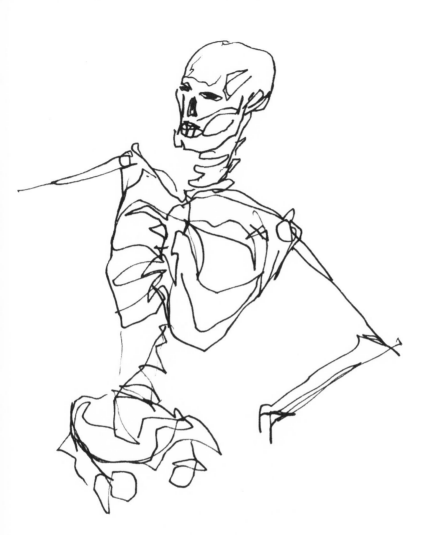

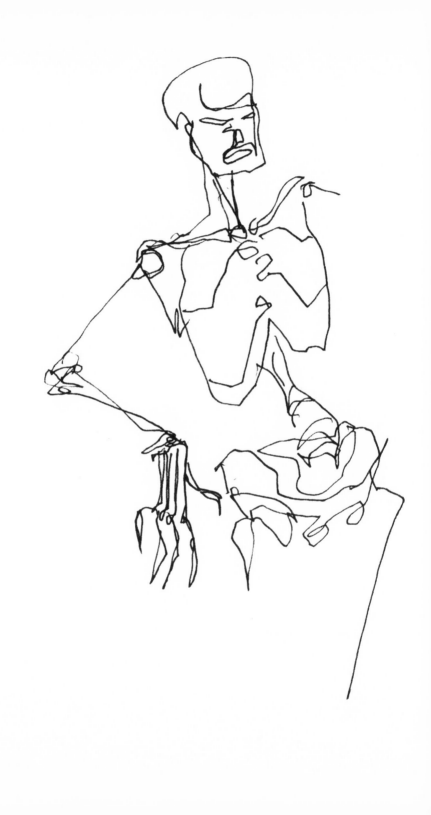

there is a force that
takes place

[symptoms] — Not to imply disease

The name

Growing
up

changes

for each

occasion

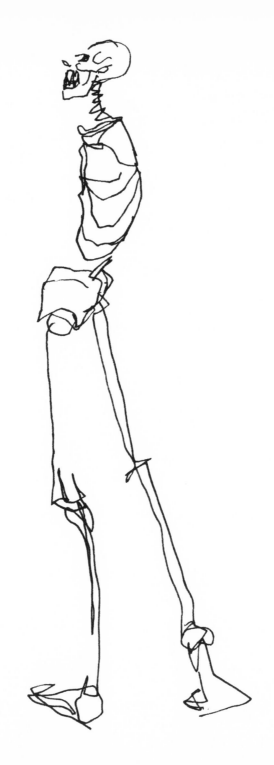

control is survival
continuing
in the present
form one
adjustes
to the l

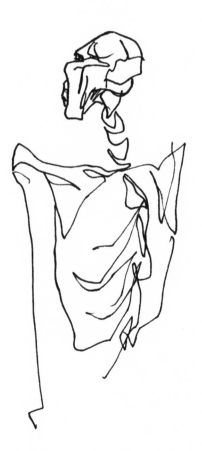

Science will
not apply here

a grasp for
tools

One communicates
with whatever is
at ones disposeall

A fight
for life

There is no name

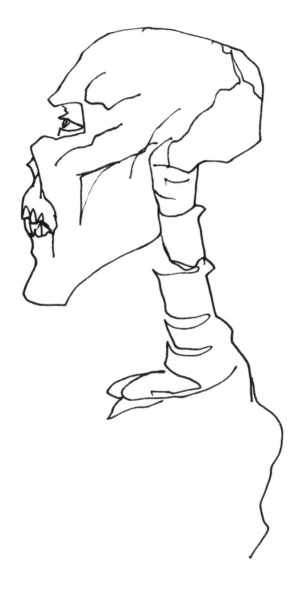

I will not die

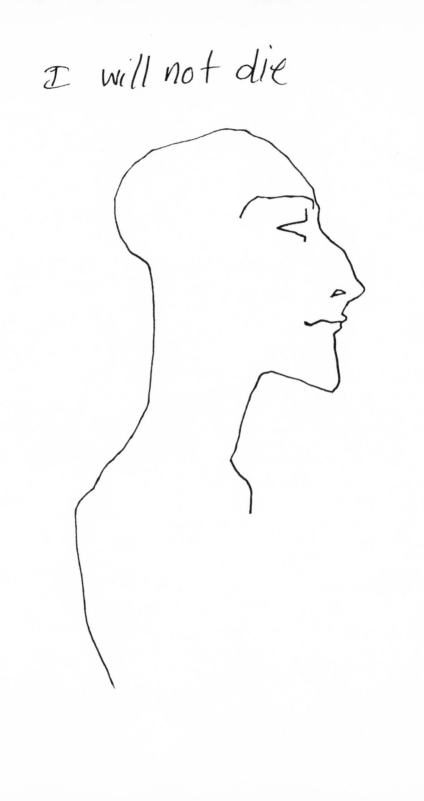

I will
Become

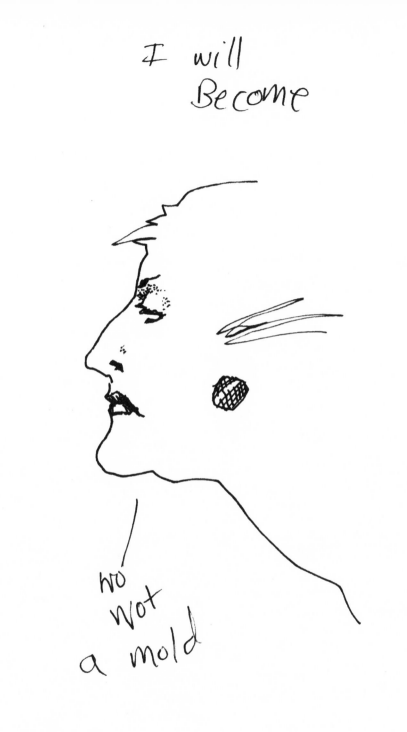

no
not
a mold

I bring the
fashion — fashioning
to
ME

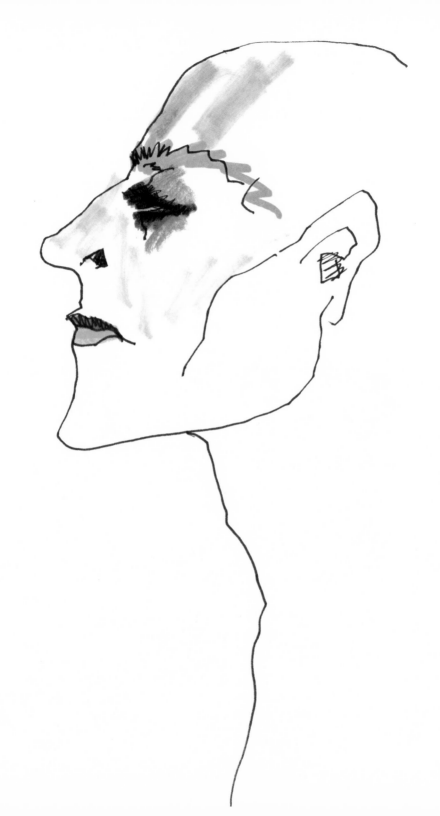

With proper
vehicle
I travel

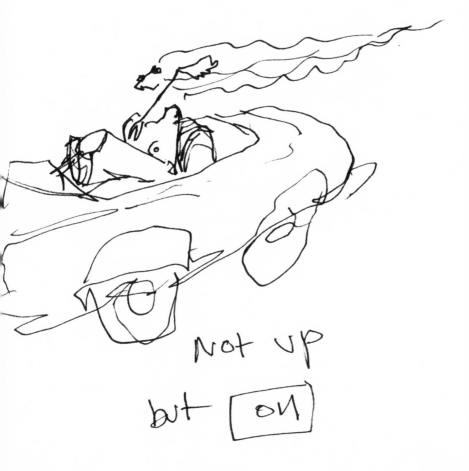

Not up
but [on]

one chooses
to go
+
sacrifice

or to stay
+
sacrifice

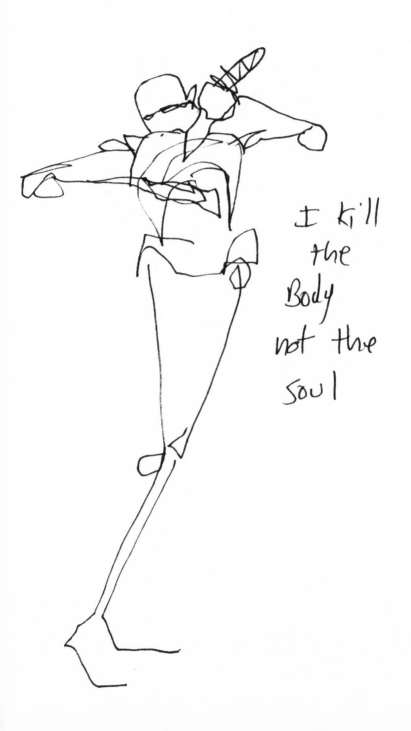

I kill
the
Body
not the
soul

Soul/
self etc.

Free's

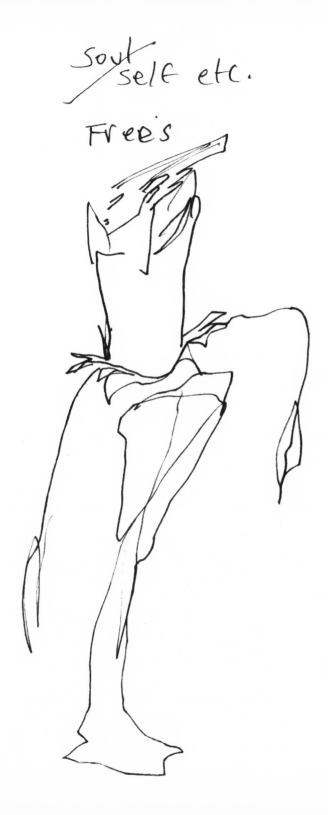

when one — Greg
knows self
Greg — one can
know others

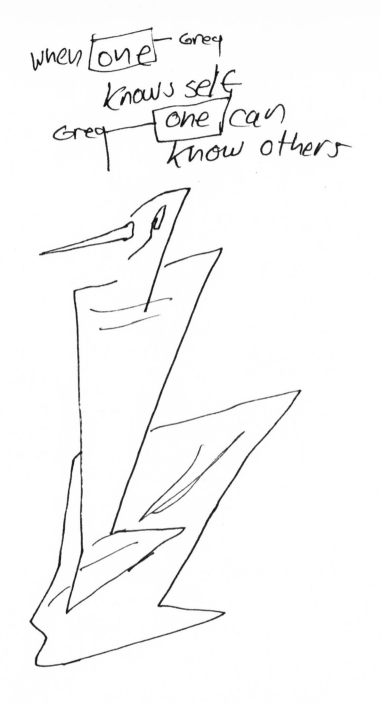

Everyone

does this

I now take
the stand

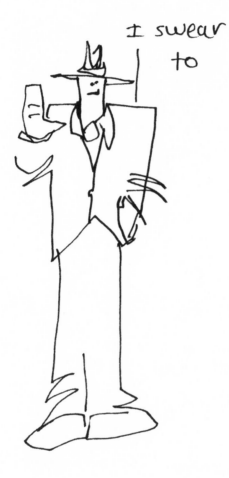

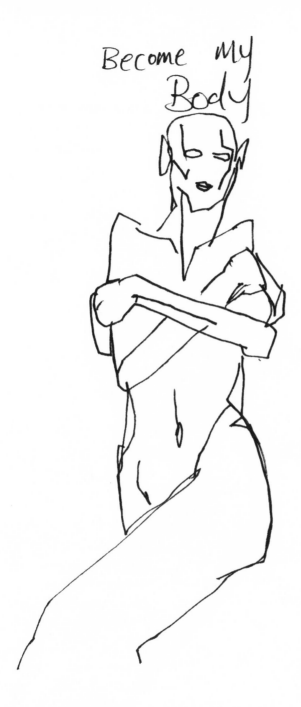

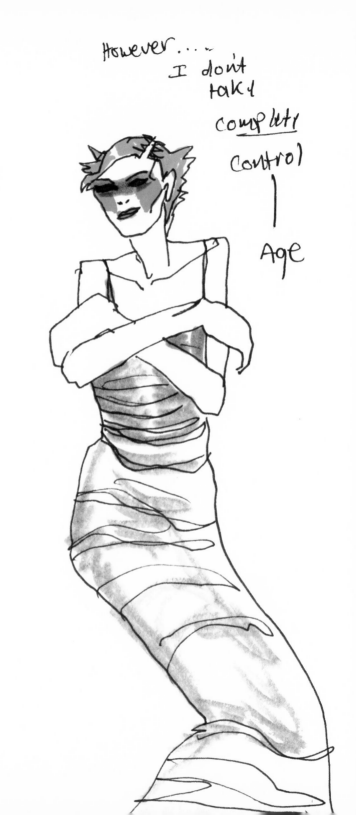

I may now begin
to live

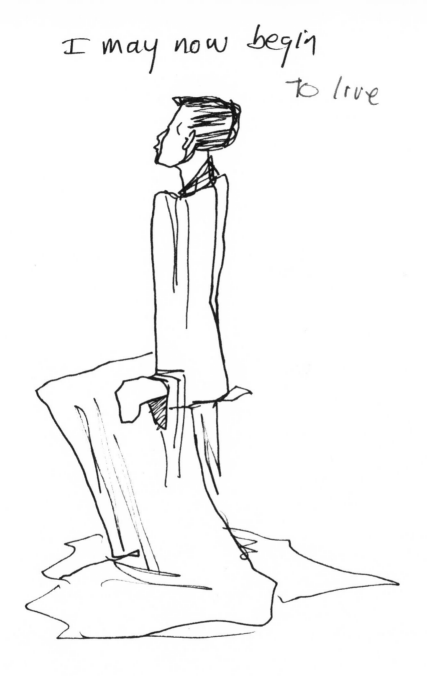

as others
 Have Before

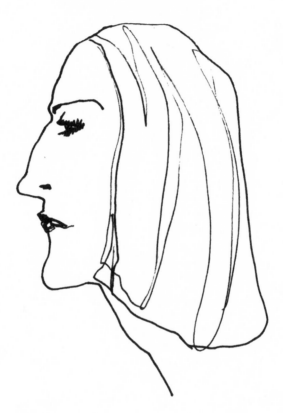

Now one does not need
constant
screwtenny/scrutiny
of
self

one

can observe
without
such deadening
Pain

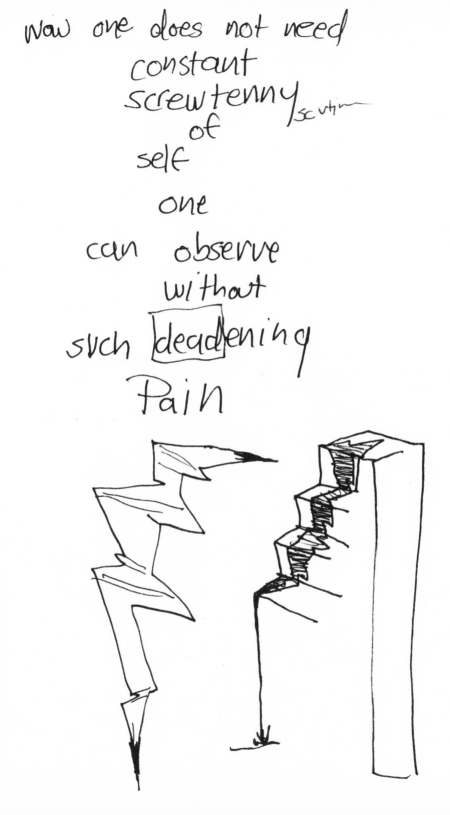

One never —

never + always
medical
no-no
(Ehrlichmen)

└─ does
what
one
does

Beware Answer's
clothe
the danger

To remove my
involvement

I can now
look at
evidence and
want weigh the
verdict — [Perry Mason]

And I do

believe to be a
women ≠ → outward to
(self) — removal
of
approval

I will be
free to continue

cause of breakdown

one constantly
breaks self
 to keep fresh

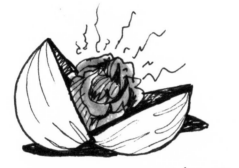

Back to lettuce

one must use knowledge as
 one sees fit.

one can handle problems
 to a degree then
someone — something
 interferes

Finding
the
Wants / Needs

Humbling self
to keep
prespective
as
dream becomes
reality.

Dreams continue
while the
reality flows

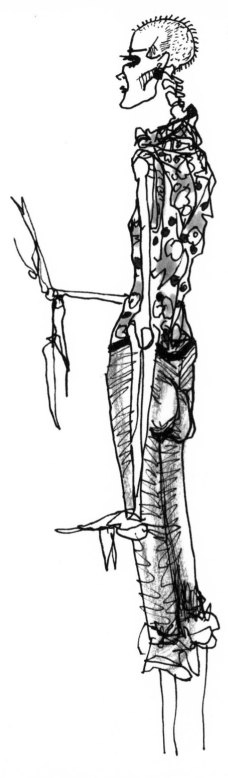

she asked
the
question
"what if?"

To know what is
I've had to know
what isn't

current Trend
of
Exploitation
of
Bizarre —
as

I once
Exploited
ends for
now
to allow growth

Ockwell
says
step Back to see
the difference

|

This is applied to
Anatomy

/

However clever boys
apply it to girls
and discover

the difference
transends
the obvious

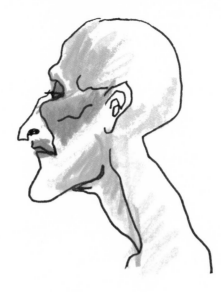

Now that I
have a
glimpse of self
I have caught
the
glimmer outside

My own body

A [model] Exploits
herself when she
manipulates large
numbers for gain with
a [trick] in mind
I as a [model] with
not Exploit self or others
Except for gain I deem
appropriate

I will not take unless
I see fit.

This is [becoming] - appearance
my opinion

one
controls
self
than helps

others
or the
help from
other's

controls
self

To understand is not to
become dull.

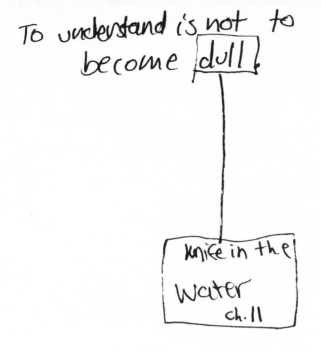

knife in the
water
ch. 11

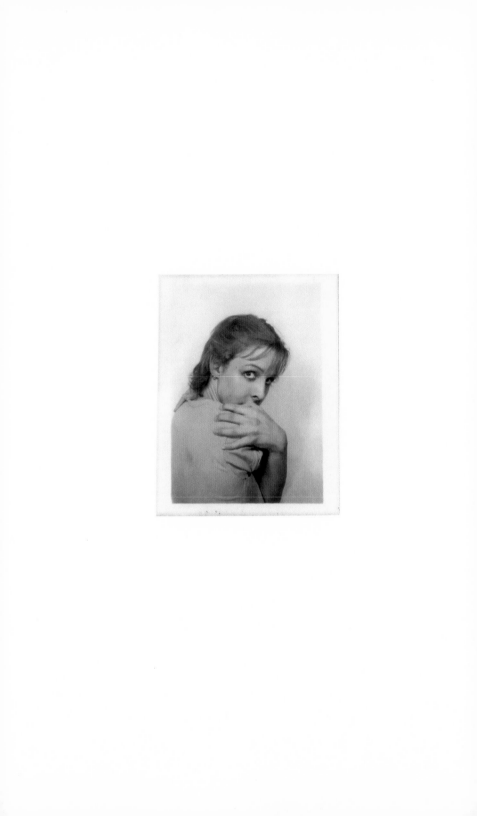

I met Greer Lankton, Greg at the time, in the fall of 1966, when the Lankton family moved in across the street in Park Forest, Illinois. Mr. Lankton asked my brothers and me to help move small cardboard boxes of candy bars out of their garage, and we passed them to him as he stacked them in a van. He was a reverend and the director of Presbyterian Camps in Saugatuck, Michigan. That's where the candy was going. I don't remember talking to the Lankton kids then—it was more like staring at them. I was very shy. I was seven years old, Greer was eight, and we were about to start the third grade. She was very cute, small, and thin, with light blonde hair that she wore a little longer than the other boys our age. Instantly, I had a crush on her. When we were done filling the van, I happily accepted a box of the unwrapped Baby Ruths as a sweet thank-you for my work.

Greer and I took the same path to school, but I would walk several paces behind her. I remember in the winter walking in her footprints in the snow. That made me feel close to her, back when I was too shy to interact. She walked with a bounce in her step; she was full of energy. At school, though, we were both quiet kids.

She was singled out as an outstanding artist in our grade, and everyone was impressed. But that didn't stop her from being bullied in school. At recess, she would sit on the ground and play with troll dolls rather than join the other boys for football in the playground. She ignored the bullying and just carried on.

In fourth grade our class put a newsletter together called *The Fourth Grade Informer.* Greer was assigned the fashion section, a page she titled "'68 Fashions," and drew boys and girls wearing the then-fashionable mod designs. In junior high, once our friendship really began, we discovered the thrill of buying clothes at the Presbyterian Church rummage sale. Since we never seemed to have any money, we were very proud and happy that we could each buy a coat for a dollar along with other accessories for a few cents. That began Greer's lifelong obsession with thrift stores. Once we could drive, we would go to nearby Chicago Heights and linger in the AMVETS Thrift Store. Greer would buy clothes there and use her mother's sewing machine to alter them.

145

By the spring of seventh grade, we had embarked on a romantic relationship that would last eighteen months, though we remained friends until the end of Greer's life. We would walk together from the bus stop to our respective homes, and as soon as I came in the door, the phone would be ringing. It was Greer, calling me to ask if I wanted to come over—she never liked to be alone. We would watch TV on her family's twelve-inch color set that sat on a cart. We watched many movies and shows, like *Night Gallery, Alfred Hitchcock Presents, All in the Family*. On Saturday afternoons we would dance along to *Soul Train*. Sometimes Greer would say she wanted to cry on purpose, so we would play the Lennon song "Jealous Guy" over and over and shed tears to it.

One thing we had in common was that we were both artists. We fully immersed ourselves in a world of creativity. In high school, we started exploring many different types of art-making. We would walk a few miles to the art supply store to get pens and sketch pads, if we could afford them. We picked up R. Crumb's *Zap Comix* and copied his style. We practiced cross-hatching and shading. We drew things to try to make each other laugh. During the winter quarter, we took the school bus daily in the afternoon to train in commercial art at a vocational school. We learned how to draw 3D lettering and other advertising skills. There were ceramics, filmmaking, and photography classes—we took them all. We had begun experimenting with making candles and wax sculptures of people. We would melt crayons to get the right colors. We did a lot of tie-dying of clothes and learned how to make batik.

It was during high school, too, that Greer started to make her first dolls. She would get T-shirt material and dye it or paint it for skin tone, then stuff it with cotton and foam and sew the pieces together into her soft doll sculptures. She gave me her first doll, which she had named Boneless Betty. After that, she started to build bone structures in the dolls using coat hangers. At Ace Hardware, Greer bought figurines and painted their faces; she did the G.I. Joes' makeup and made them look like women with her acrylic paints. She also altered the Walton family figurines and added a lot of makeup to them. The local library eventually set up a display with several of Greer's soft sculptures, and there was a write-up about them in the local paper. Greer told me she was going to be famous someday. I believed her.

A few years later, we made several films featuring Greer's dolls. We found out that we could buy Super 8 black-and-white film and started making stop-motion animation films. One such film we made, around the time she wrote in this 1977 sketchbook, starred Greer. She wore black-and-white clothes and moved all around her living room using her ballet

and gymnastic skills. We titled the film *The Contortionist*, and it is now in the collection of the Department of Film at The Museum of Modern Art in New York.

In high school, too, Greer was discovering her sexuality. She told me she was gay but wanted me to keep it a secret. During those years, being gay was not remotely accepted. She had a lover who was popular with the girls because he was a handsome gymnastics state champ. I knew about their relationship but didn't tell anyone.

We would go to the local library and she would check out whatever books she could find on trans women. She pored over books about Renée Richards, Christine Jorgensen, and her idol, Candy Darling, and talked at length about Canary Conn's memoir. We spent a lot of time with Diane Arbus's photography books, which helped ignite Greer's intense interest in so-called freaks. Her favorite movie was, unsurprisingly, Tod Browning's 1932 film, *Freaks*.

She was an excellent gymnast and lettered in that sport. She was also in ballet classes. She convinced the dance class to let her wear pointe shoes, typically reserved for female dancers. She told me that she was never meant to be a boy because she didn't have a male brow ridge and her build was so slight. I saw a lot of physical changes in Greer near the end of high school. She experimented with dressing more femininely, tweezed her eyebrows, tried out makeup, and dyed her hair red. When we went into stores, she was often mistaken for a girl. She would act a bit offended about it and call the clerk an idiot, but she didn't seem all that upset about it after all. At school, I would see her get bullied a lot. While she was in the midst of being tormented, her whole face would change. She would have a blank expression and go into something like a trance, looking down until the yelling stopped. She was anxious to get out of high school.

Greer was able to graduate a year early, in 1975, and start classes at the Art Institute of Chicago that fall. Back at home in Park Forest for the summer of 1976, Greer worked on making a life-size female fat suit out of T-shirt material and foam that she could wear. It looked like Divine, the drag queen, and she named it Madame Eadie (later renamed Dee Dee Lux). It was a blistering hot summer and the Lanktons' house had no air conditioning. Greer asked if I would get into the suit because she needed to hand-stitch the finishing touches while someone was actually wearing it. I couldn't wait for her to finish—in the heat, the suit was almost unbearable. When it was finished, we took a series of photos of her wearing the fat suit in the backyard. Back at school, she wore it to a Halloween costume contest at the Art Institute and won first place, taking home $500.

147

This journal and sketchbook picks up in Chicago on September 9, 1977, two years into art school, at a time when she considered with great intentionality her gender transition. While she wouldn't have the surgery until 1979, she was feeling growing pressure and internal turmoil even as this sketchbook was being completed, resulting in a nervous breakdown later that month. She went on to spend five weeks at the Riverside Medical Center in Kankakee, Illinois.

When I saw her right after she got out of the hospital, she was trying to act very masculine. The doctor had told her that "she was born a boy and should act like a boy." That was not healthy for her and led to further mental distress, until she finally made the definitive decision to get gender-affirming surgery. In the pages of this sketch-book, we glimpse some of the thinking that led to this decision. On one page, alongside the sketch of a figure, she writes: "As a woman, some men will discriminate. As a sex change, many people will discriminate, but alas does it really matter?"

After witnessing the pain and anguish that came with her nervous breakdown, her friends and family knew having the surgery was not only important but essential for Greer. Her parents were supportive of her decision. In the summer of 1979, her mother brought her to Youngstown, Ohio, to one of the few surgeons who could do the surgery at the time. Her father, a reverend, was able to use his health insurance from the Presbytery of Chicago to pay for the operation.

Greer left the Art Institute in 1978, moving to New York to finish her studies at Pratt, where she earned her BFA in 1981. We kept in contact through phone calls and letters. We saw each other in Illinois during summers and holidays. I visited her once in New York. She had started using heroin and smoking crack cocaine, and had become extremely thin, as she battled with anorexia too. She had it in her mind that the thinner she got, the more feminine she would look. After a long struggle with drugs, Greer moved back to Illinois in 1990. She went through outpatient programs for drug use and anorexia. She lived with her parents.

When Greer moved back home, I would stay with her a few days here and there at her family home. Greer was very good to my young children, and they loved her. She repaired my son's favorite torn blanket. She painted my daughter's fingernails to match hers and put lipstick on her. They both loved looking pretty!

She finally got clean and was prolific while living in Illinois, showing her dolls in two biennials—at the Whitney Museum of American Art and in Venice—and participating in several important group shows. When she had art in the exhibition *Heterogeneous: An Exhibit by Gay, Lesbian,*

Bisexual, and Transgender Artists at the University of Minnesota in February 1996, her parents drove her up and helped her install her work, and she stayed with me for the week in Minneapolis. When she got back to Chicago, she fell deeper into drugs and she called asking me for money. I knew it was for drugs. Her voice was very edgy.

When Greer died in November 1996, she overdosed, and it was declared a suicide.

The Lankton family donated Greer's large collection of dolls, paintings, drawings, photos, letters, and datebooks to the Mattress Factory art museum in Pittsburgh, where her final art installation, *It's All About ME, not you*, is permanently displayed. In 2020 the Mattress Factory received a large grant from the Council on Library and Information Resources (CLIR) and digitized the entire archive, which is now online.

Over the years, I have remained close with the Lankton family. After Greer had the surgery, Mr. and Mrs. Lankton used to call me their third daughter. I was impressed with how loving and supportive they were with all of their children. It was a calm household, with a lot of good food and laughter. I always felt welcomed, included, and loved.

After Greer's death, the Lankton family gifted me twenty-one years' worth of Greer's journals, including this sketchbook. I decided to transcribe them into a digital file, which took a couple of years. Often it was emotionally difficult to get through them. I would cry when I read about how much pain she was in. After I finished, I had a typed document of well over five hundred pages. The original journals and transcriptions are now in the collection of the Department of Film at The Museum of Modern Art.

Greer had a beautiful spirit and I miss her every day. But as she writes in these pages, "I will not die, I will become."

Greer Lankton, Sketchbook, September 1977
© 2023 Greer Lankton and Joyce Randall Senechal

ISBN: 979-8-9876249-1-3

Afterword
© 2023 Joyce Randall Senechal

Sketchbook, September 1977 appears courtesy The Museum of Modern Art, New York.

Photograph of Greer Lankton, c. 1977, on Page 144 courtesy The Greer Lankton Collection, Mattress Factory Museum, Pittsburgh.

Managing Editor (2023): Rachel Valinsky
Managing Designer (2023): Siiri Tännler
Copy Editor: Allison Dubinsky

Primary Information
232 3rd St, #A113
The Old American Can Factory
Brooklyn, NY 11215
www.primaryinformation.org

Printed by Grafiche Veneziane, Italy

Primary Information would like to thank Sophie Cavoulacos and Ron Magliozzi in the Department of Film at The Museum of Modern Art, Sarah Hallett at the Mattress Factory, and Joyce Randall Senechal.

Primary Information is a 501 (c)(3) non-profit organization founded in 2006 to publish artists' books and writings. The organization's programming advances the often-intertwined relationship between artists' books and arts' activism, creating a platform for historically marginalized artistic communities and practices. The organization receives generous support through grants from the Michael Asher Foundation, Galerie Buchholz, the Patrick and Aimee Butler Family Foundation, The Cowles Charitable Trust, Empty Gallery, The Fox Aarons Foundation, Helen Frankenthaler Foundation, Furthermore: a program of the J. M. Kaplan Fund, the Graham Foundation for Advanced Studies in the Fine Arts, Greene Naftali, the Greenwich Collection Ltd, the John W. and Clara C. Higgins Foundation, Metabolic Studio, the New York City Department of Cultural Affairs in partnership with the City Council, the New York State Council on the Arts with the support of the Office of the Governor and the New York State Legislature, the Orbit Fund, the Stichting Egress Foundation, VIA Art Fund, The Jacques Louis Vidal Charitable Fund, The Andy Warhol Foundation for the Visual Arts, the Wilhelm Family Foundation, and individuals worldwide. Primary Information receives support from the Willem de Kooning Foundation, the Marian Goodman Foundation, the Henry Luce Foundation, and Teiger Foundation through the Coalition of Small Arts NYC (CoSA NYC).